Table of Contents:

INTRODUCTION . 1
Chapter 1, Shapes. . 2
Shape #1. 3
Shape #2. 4
Shape #3. 5
Shape #4. 6
Shape #1 With 4th Finger . 7
Shape #2 With 4th Finger . 8
Shape #3 With 4th Finger . 9
Shape #4 With 4th Finger . 10
Shape #4 With Low 4th Finger . 11
Shape #4 With 4th Finger, and 4th Finger Extended . 12
Chapter 2, One Octave Major Scales . 13
A Major Scale and Arpeggio (Upper Octave). 14
D Major Scale and Arpeggio. 14
G Major Scale and Arpeggio (Lower Octave) . 15
C Major Scale and Arpeggio (Lower Octave) . 16
G Major Scale and Arpeggio (Upper Octave) . 16
Bb Major Scale and Arpeggio (Lower Octave) . 17
F Major Scale and Arpeggio . 17
C Major Scale and Arpeggio (Upper Octave). 18
A Major Scale and Arpeggio (Lower Octave) . 18
E Major Scale and Arpeggio . 19
B Major Scale and Arpeggio (Upper Octave). 19
Gb Major Scale and Arpeggio (In 1/2 Position) . 20
B Major Scale and Arpeggio (Lower Octave in 1/2 Position) . 20
B Major Scale and Arpeggio (Lower Octave in 1st Position) . 21
Bb Major Scale and Arpeggio (Upper Octave) . 22
Eb Major Scale and Arpeggio . 22
Ab Major Scale and Arpeggio (Lower Octave) . 23
Db Major Scale and Arpeggio (Lower Octave) . 24
Ab Major Scale and Arpeggio (Upper Octave) . 24
Db Major Scale and Arpeggio (Upper Octave) . 25
Chapter 3, Major Scales and Arpeggios in First Position . 26
G Major Scale, Arpeggio, and Pentatonic. 27
D Major Scale, Arpeggio, and Pentatonic . 28
A Major Scale, Arpeggio, and Pentatonic. 29
C Major Scale, Arpeggio, and Pentatonic. 30
F Major Scale, Arpeggio, and Pentatonic. 31
Bb Major Scale, Arpeggio, and Pentatonic. 32
E Major Scale, Arpeggio, and Pentatonic. 33
B Major Scale, Arpeggio, and Pentatonic. 34
Eb Major Scale, Arpeggio, and Pentatonic. 35
Ab Major Scale, Arpeggio, and Pentatonic. 36
Db Major Scale, Arpeggio, and Pentatonic. 37

Introduction

In this book we are going to learn about many different types of "shapes," scales, arepeggios, and pentatonic scales. The information is presented in a certain order, but feel free to pursue whatever order of information seems most useful.

Chapter 1

Shapes

Shape #1

Shape #2

Shape #3

Shape #4

Shapes With 4th Finger

Keep in mind as you play through these shapes that what we are really dealing with are finger placements, and more importantly, intervals.

Shape #1

Think of shape #1 as a two whole steps and a half step from the open string including the open string.

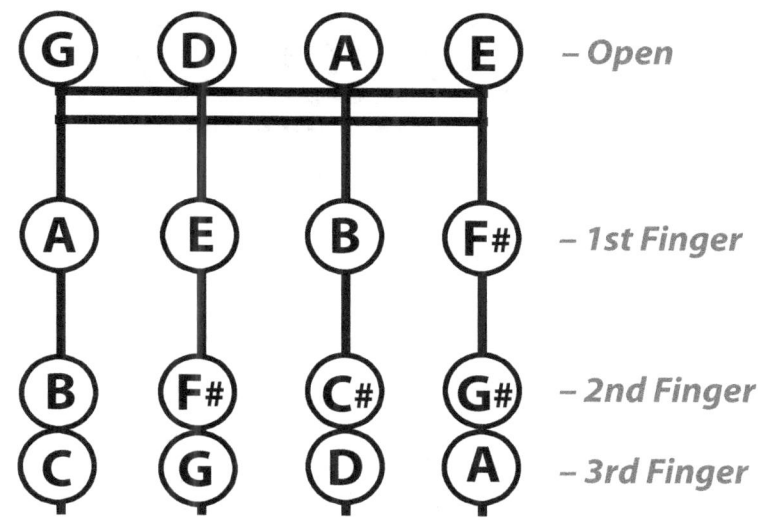

(On the E String)

(On the A String)

(On the D String)

(On the G String)

Shape #2

Think of shape #2 as a whole step, a half step, and a whole step from the open string including the open string.

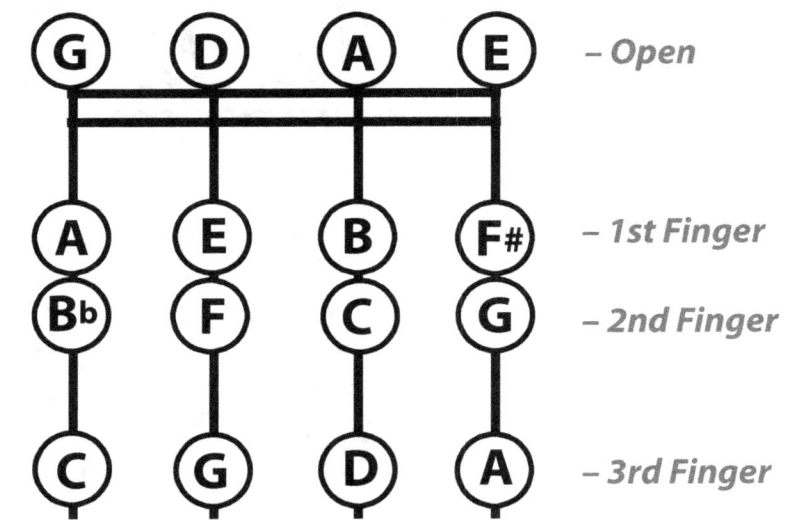

(On the E String)

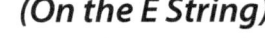
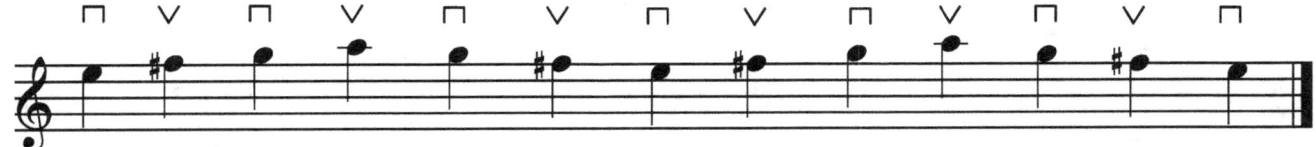

(On the A String)

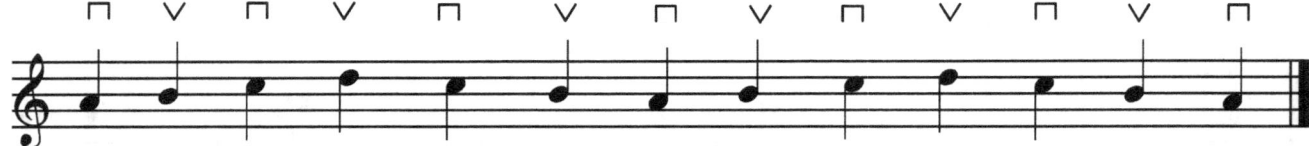

(On the D String)

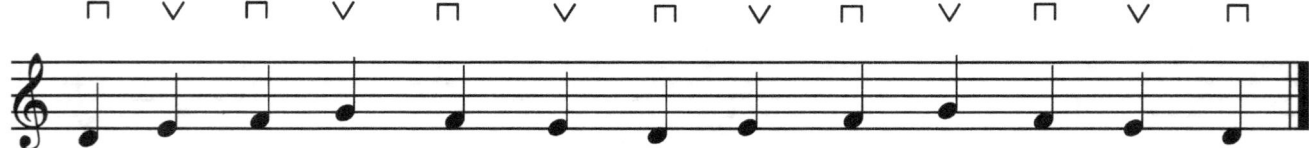

(On the G String)

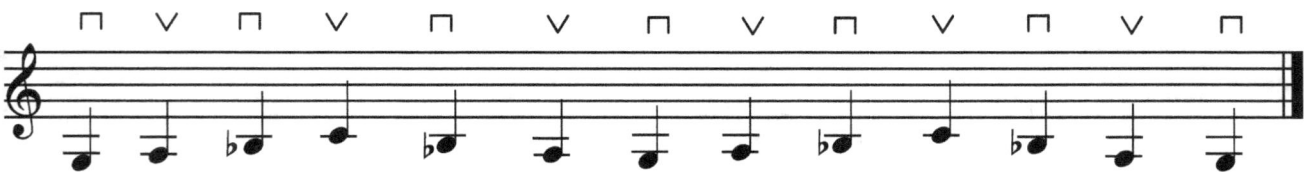

Shape #3

Think of shape #3 as three whole steps in a row from the open string including the open string.

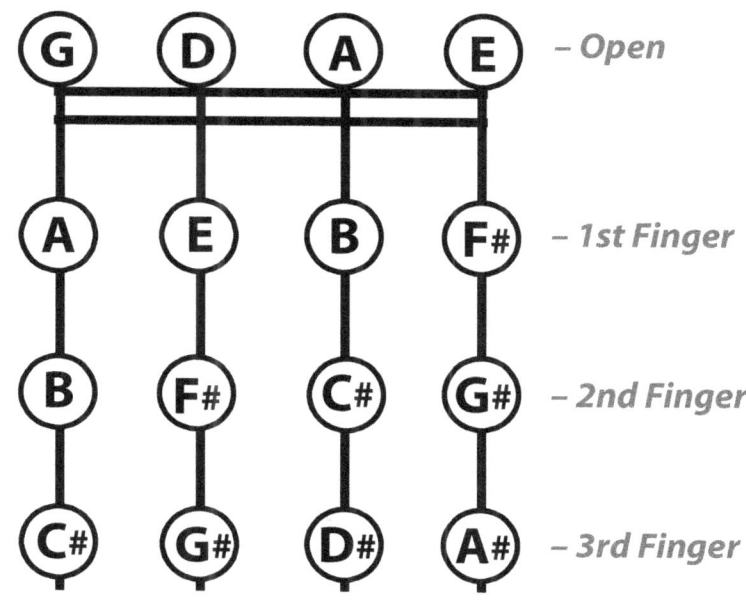

Shape #4

Think of shape #4 as a half step, and two whole steps from the open string including the open string.

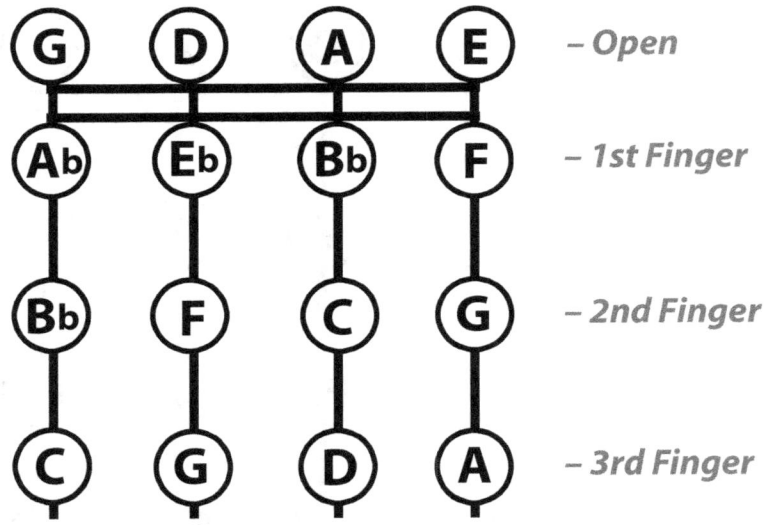

Shape #1 With 4th Finger

Think of shape #1 as a two whole steps and a half step from the open string including the open string.

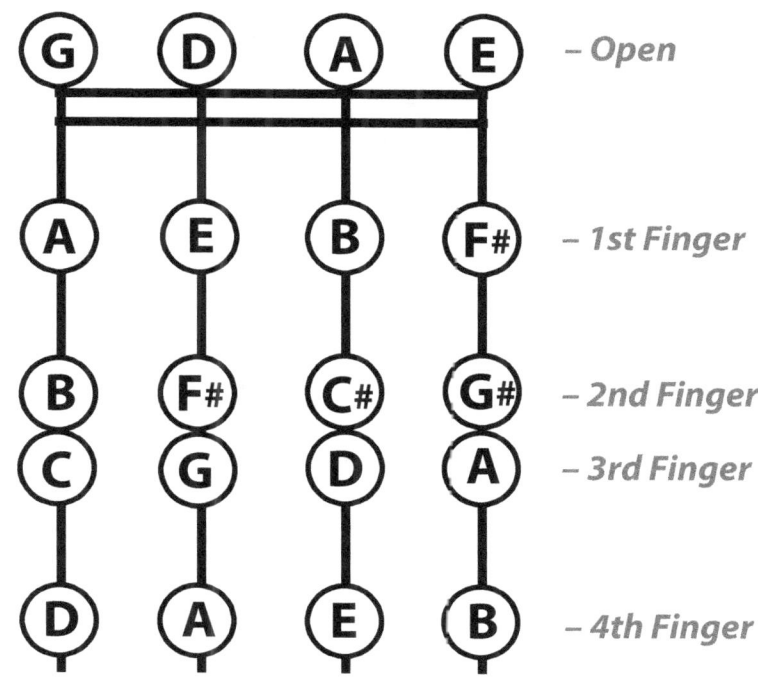

Shape #2 With 4th Finger

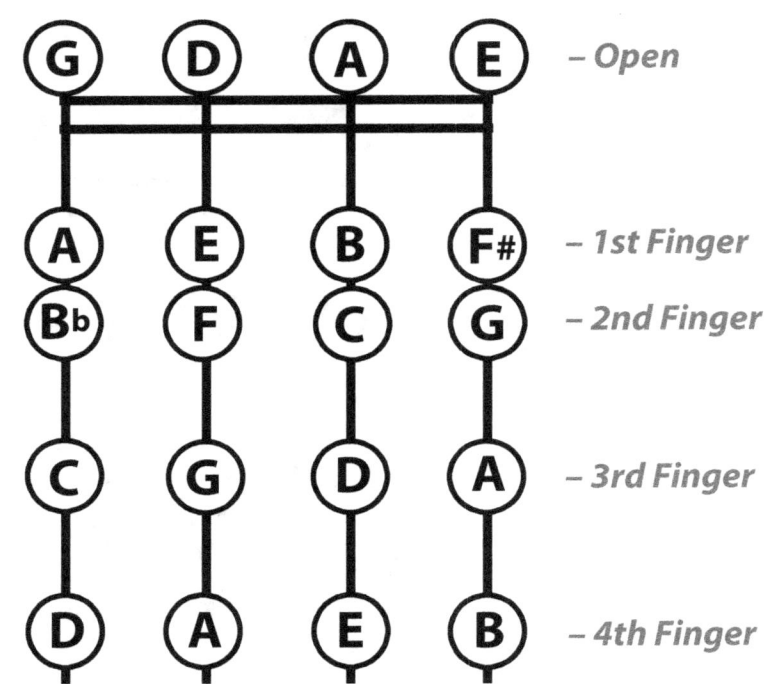

Shape #3 With 4th Finger

Think of shape #3 as three whole steps in a row from the open string including the open string.

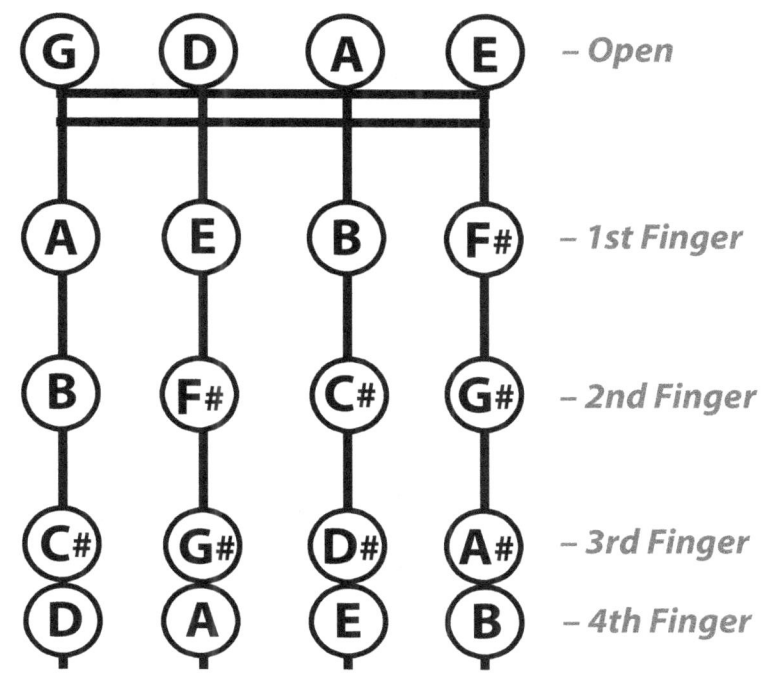

Shape #4 With 4th Finger

Think of shape #4 as a half step, and two whole steps from the open string including the open string.

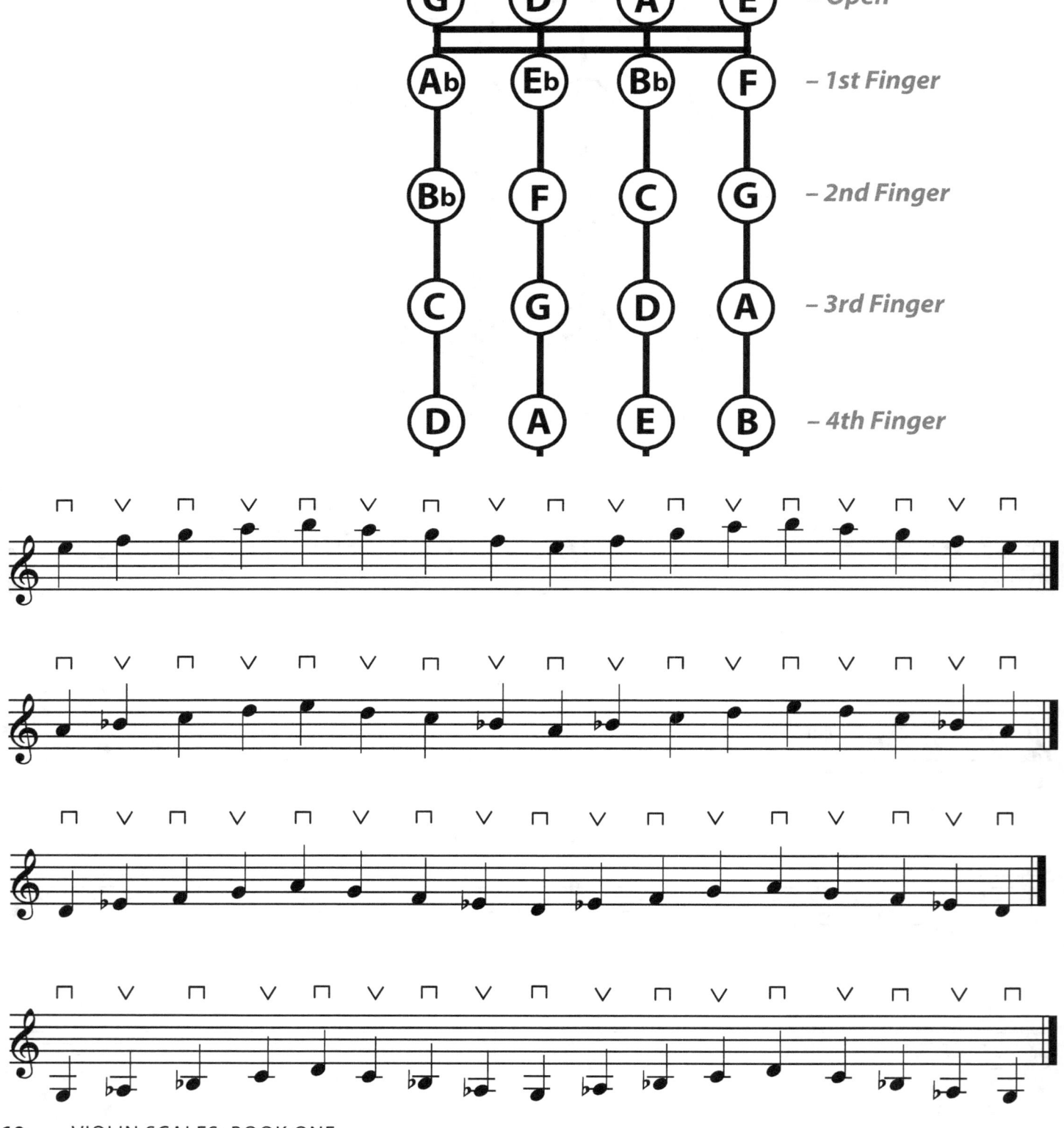

Shape #4 With Low 4th Finger

Now the 4th finger is going to be in the lower position.
The intervals are HWWH.

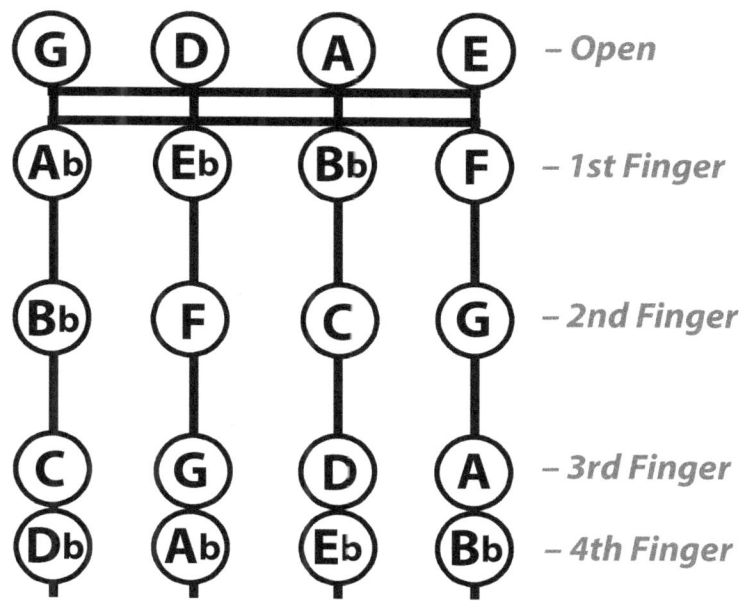

Shape #4 With 4th Finger, and 4th Finger Extended

Think of shape #4 as a half step, and two whole steps from the open string including the open string.

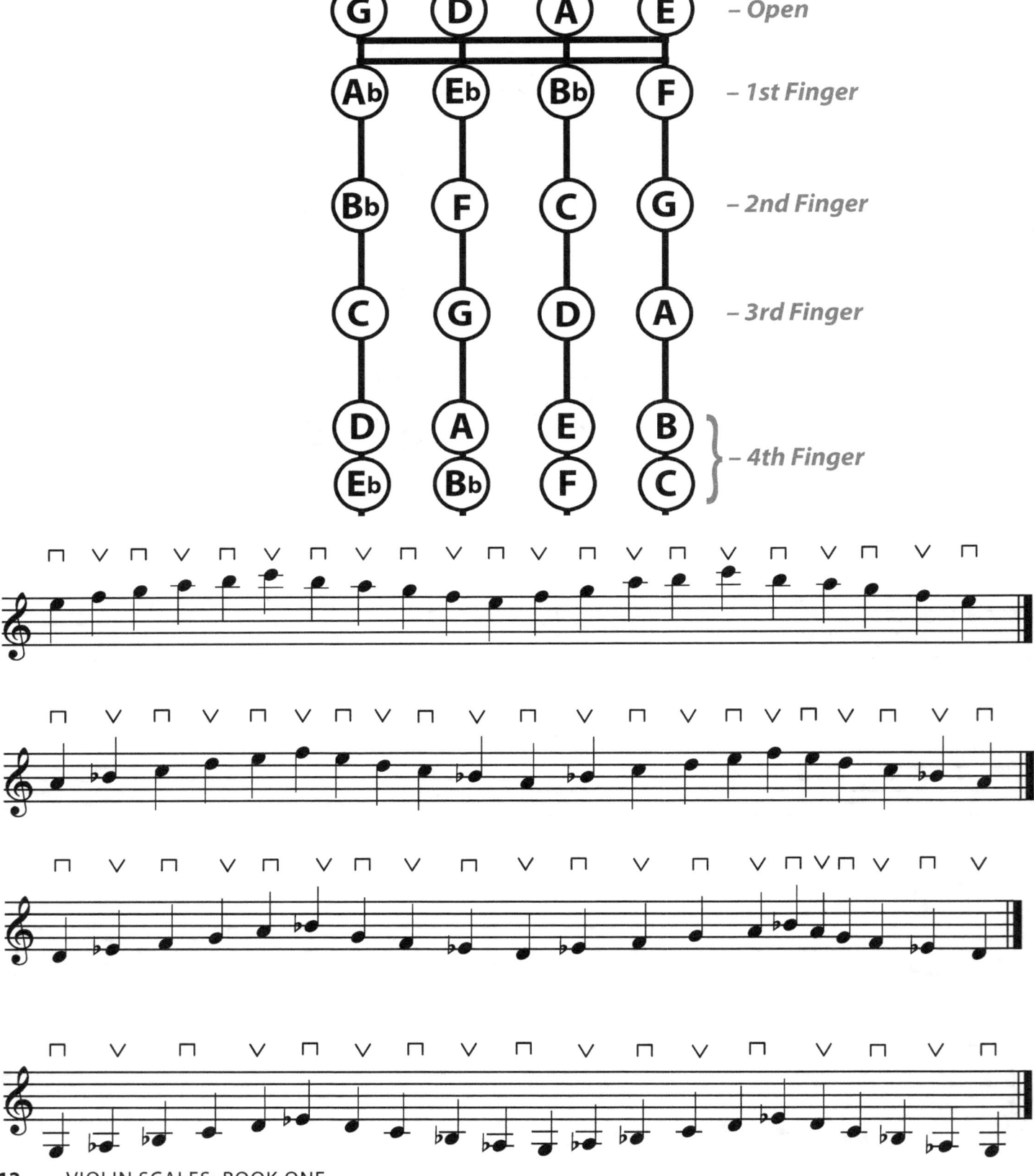

VIOLIN SCALES: BOOK ONE

Chapter 2
One Octave Major Scales

Here we are covering major scales at one octave as found on the violin in first position. Even if you have already learned some of these at some point, please review them.

A major (Upper Octave)
D major
G major (Lower Octave)
C major (Lower Octave)
G major (Upper Octave)
Bb major (Lower Octave)
F Major
C major (Upper Octave)
A major (Lower Octave)
E Major
B major (Upper Octave)
Gb major
B major (Lower Octave in 1/2 Position)
B Major (Lower Octave in First Position)
Bb major (Upper Octave)
Eb Major
Ab Major (Lower Octave)
Db Major (Lower Octave)
Ab major (Upper Octave)
Db major (Upper Octave)

The scales that are not designated "lower" or "upper" octaves have only one complete octave in first position.

VIOLIN SCALES: BOOK ONE 13

A Major Scale and Arpeggio (Upper Octave):

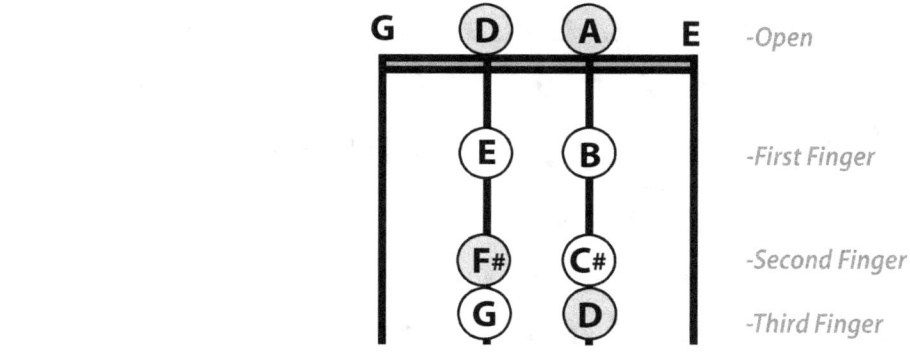

In these diagrams the notes and finger positions of the scale are shown. The arpeggio notes have been colored in to show their position.

D Major Scale and Arpeggio:

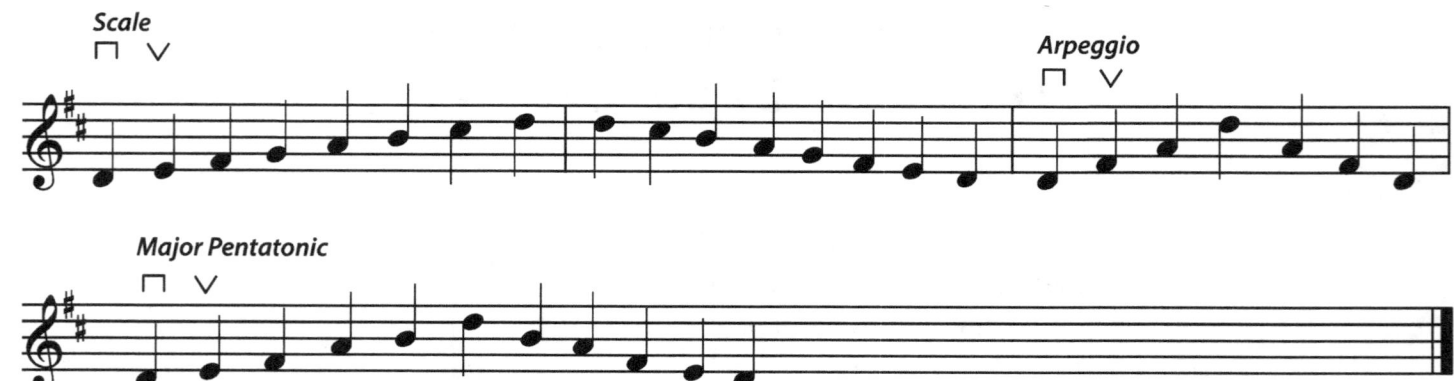

G Major Scale and Arpeggio (Lower Octave):

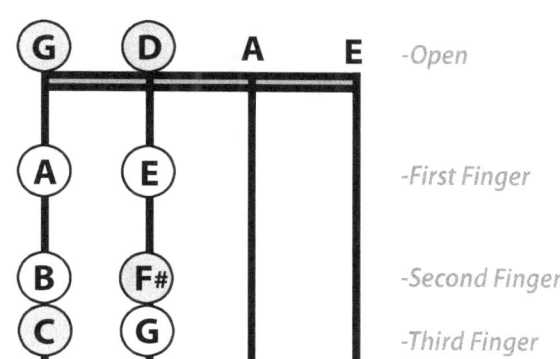

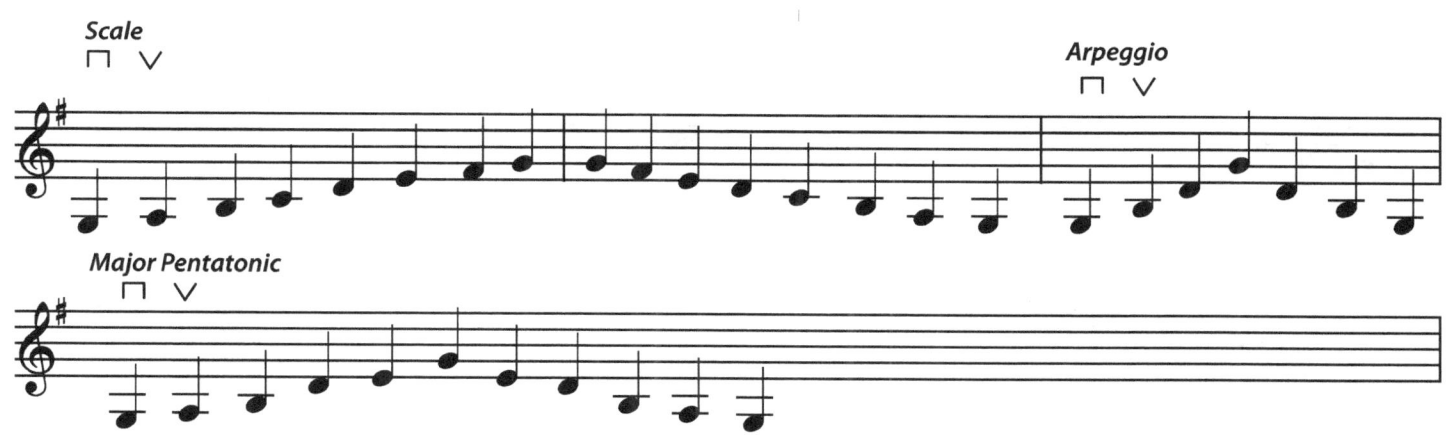

C Major Scale and Arpeggio (Lower Octave):

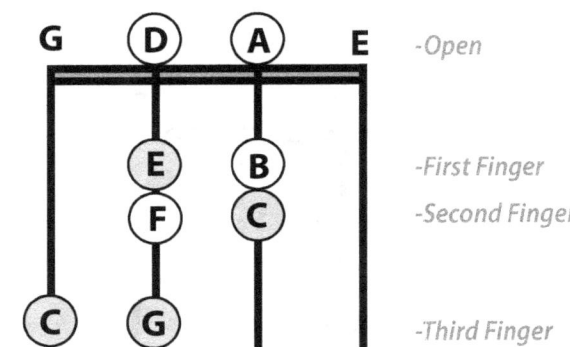

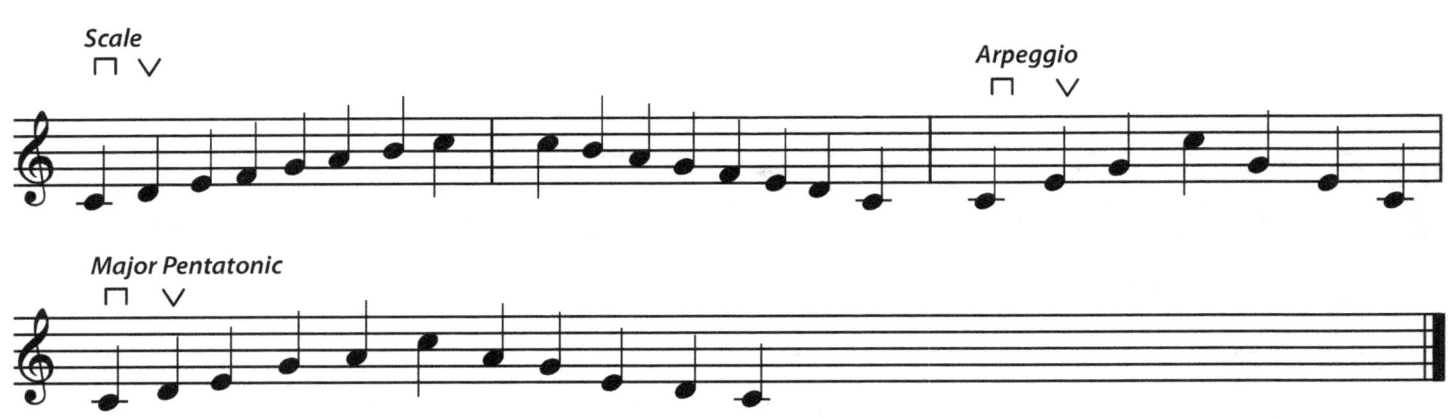

G Major Scale and Arpeggio (Upper Octave):

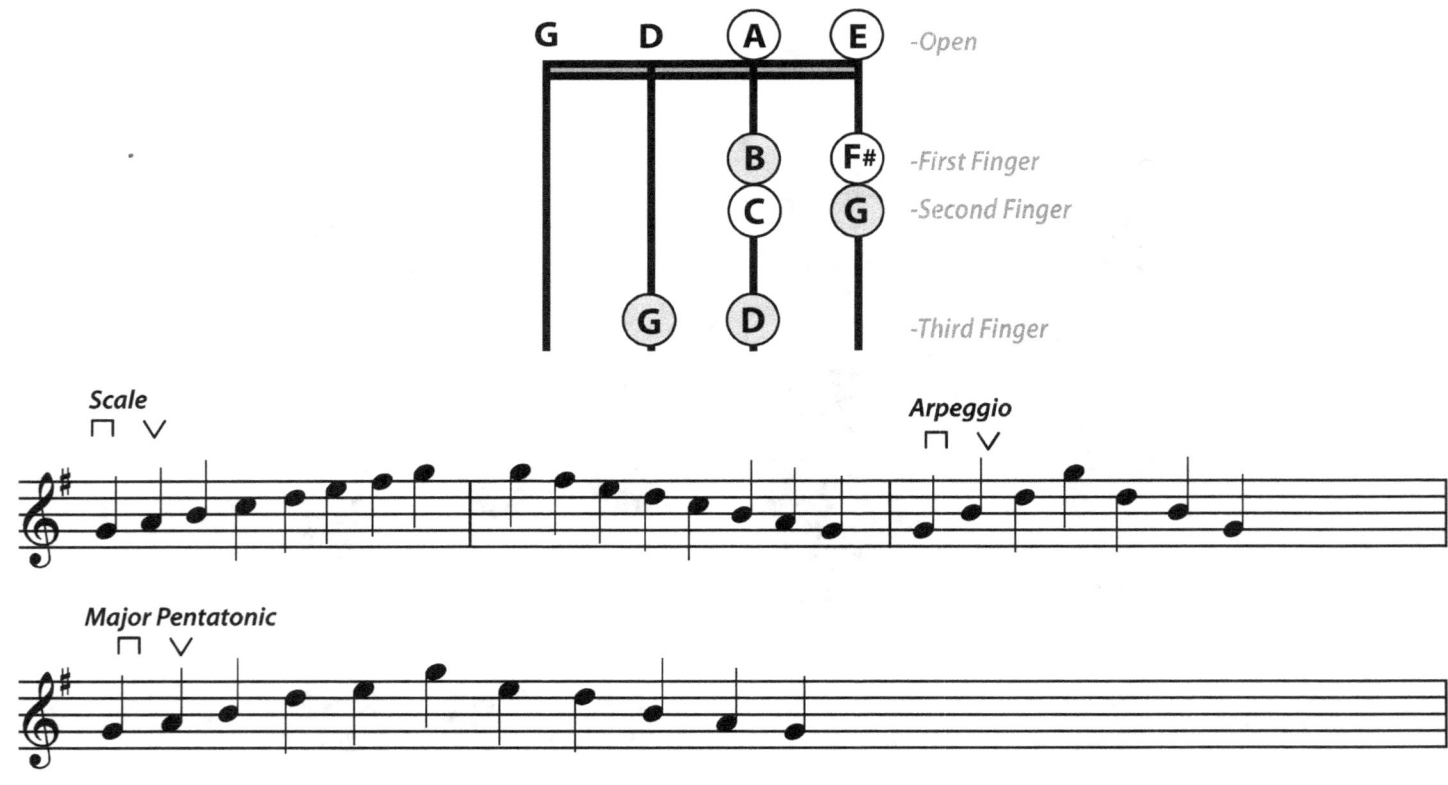

Bb Major Scale and Arpeggio (Lower Octave):

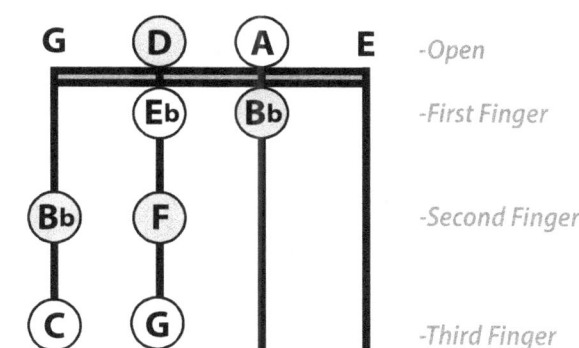

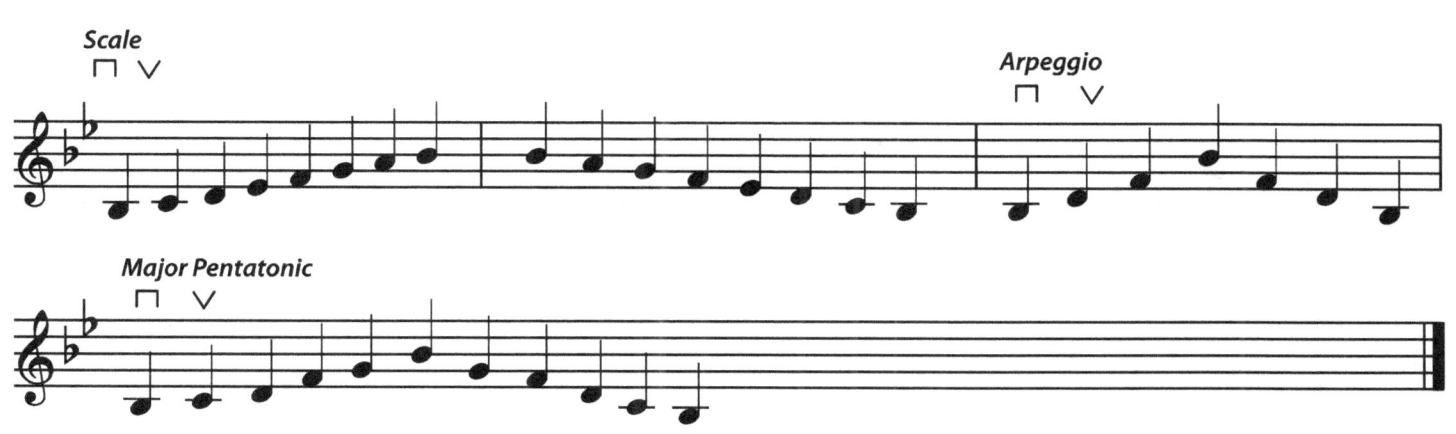

F Major Scale and Arpeggio:

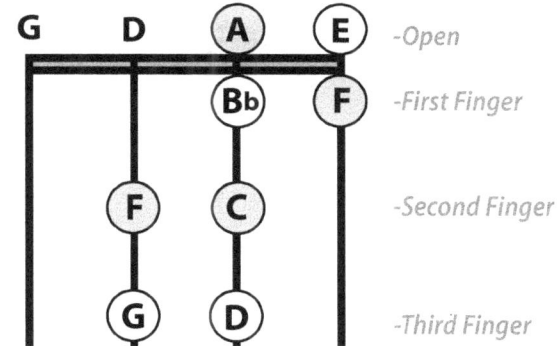

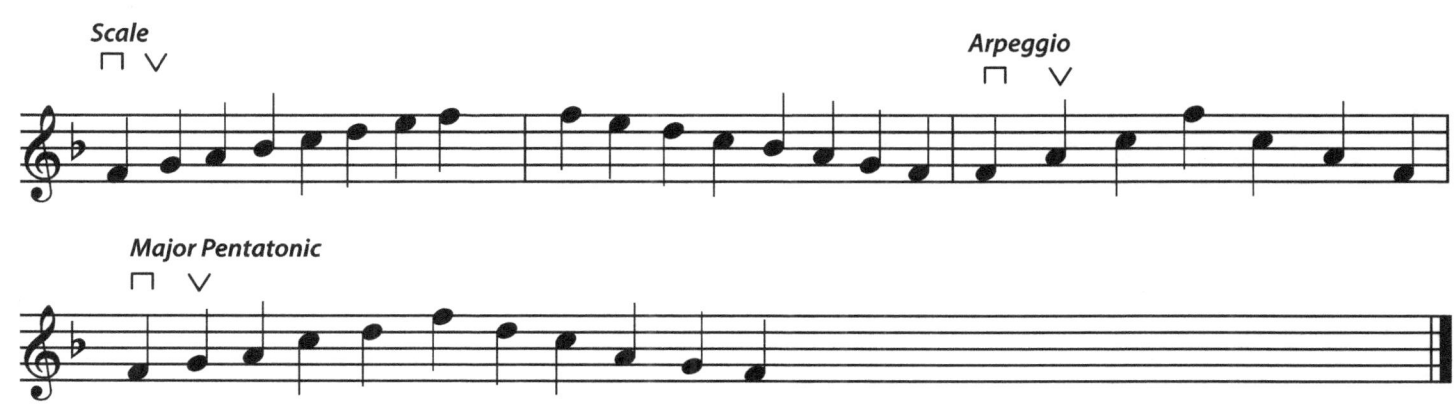

VIOLIN SCALES: BOOK ONE

C Major Scale and Arpeggio (Upper Octave):

Scale

Arpeggio

Major Pentatonic

A Major Scale and Arpeggio (Lower Octave):

Scale

Arpeggio

Major Pentatonic

E Major Scale and Arpeggio:

Scale

Arpeggio

Major Pentatonic

B Major Scale and Arpeggio (Upper Octave):

Scale

Arpeggio

Major Pentatonic

Gb Major Scale and Arpeggio (In 1/2 Position):

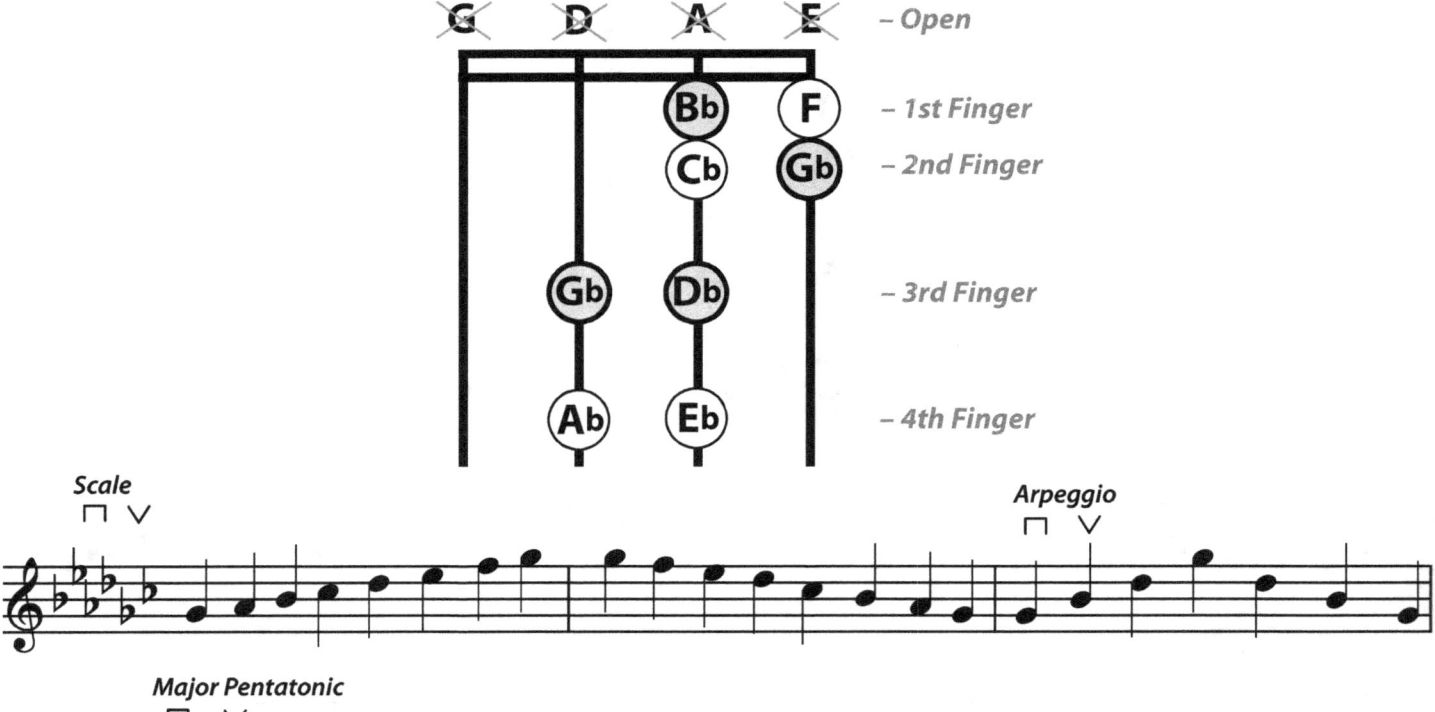

B Major Scale and Arpeggio (Lower Octave in 1/2 position):

B Major Scale and Arpeggio (Lower Octave in First position):

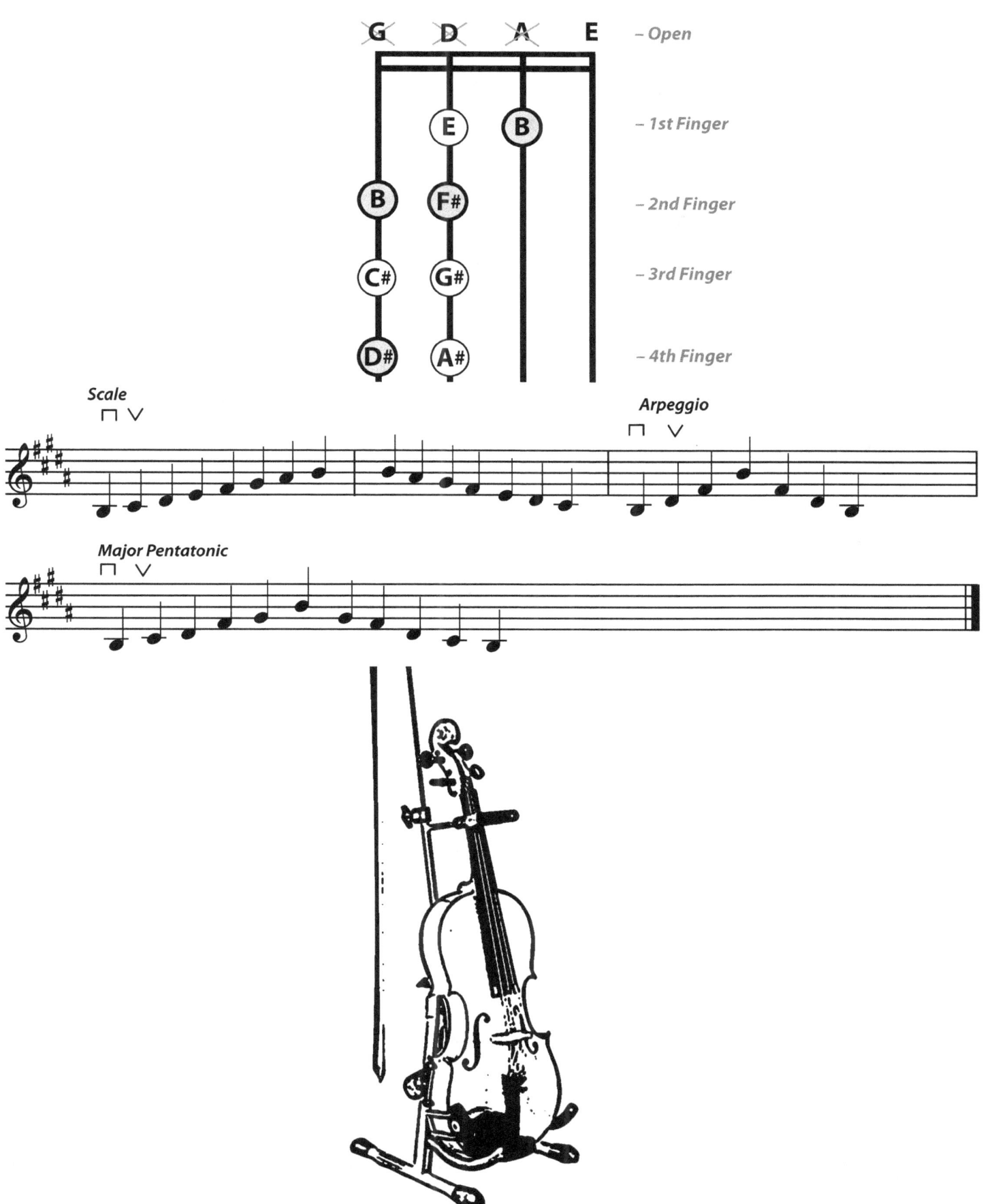

Bb Major Scale and Arpeggio (Upper Octave):

Scale

Arpeggio

Major Pentatonic

Eb Major Scale and Arpeggio:

Scale

Arpeggio

Major Pentatonic

VIOLIN SCALES: BOOK ONE

Ab Major Scale and Arpeggio (Lower Octave):

Scale

Arpeggio

Major Pentatonic

Db Major Scale and Arpeggio (Lower Octave):

Ab Major Scale and Arpeggio (Upper Octave):

VIOLIN SCALES: BOOK ONE

Db Major Scale and Arpeggio (Upper Octave):

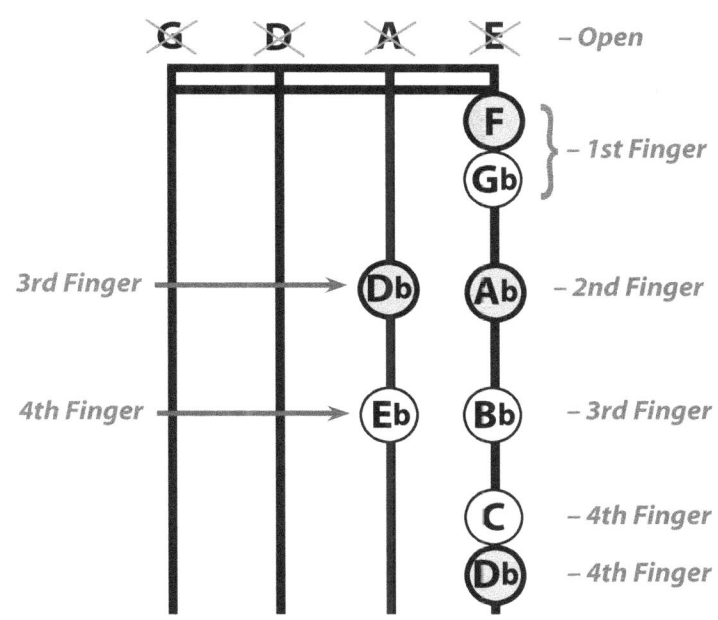

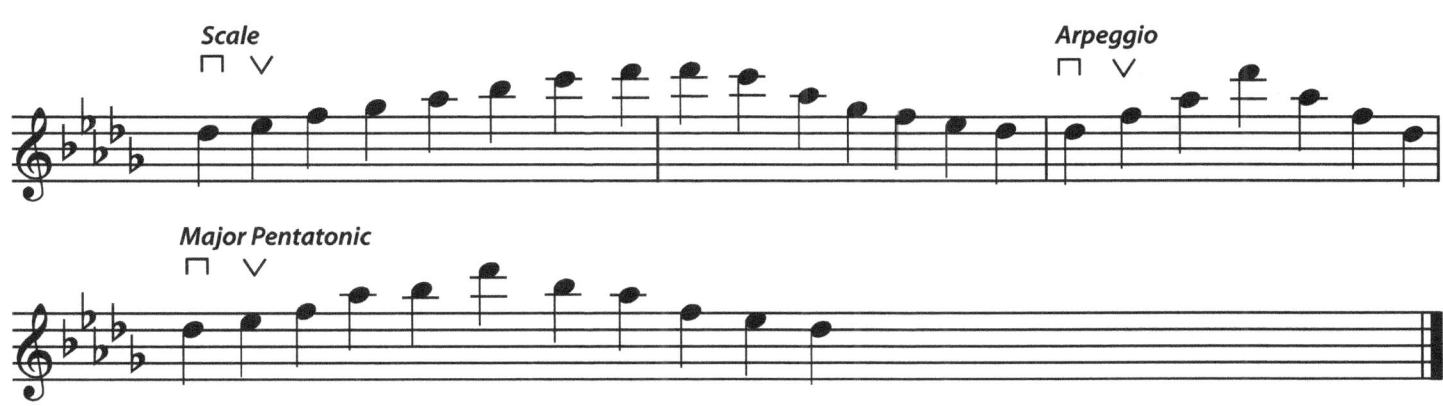

Chapter 3
Major Scales and Arpeggios in First Position

G, D, A, and C

F, Bb, E, and B

Eb, Ab, Db, and Gb

> When playing through these scales, start and end the scale on the lowest available root in first position, but only after playing all available notes in first position. For G major this is open G; for D major this note would be open D. For most of these keys the lowest available root will not be an open string. This will also be applied to the arpeggio and major pentatonic.

1 — 2 — 3 — 4 — 5 — 6 — 7 — 8
W W H W W W H

VIOLIN SCALES: BOOK ONE

G Major Scale, Arpeggio, and Pentatonic:

*In these diagrams the notes and finger positions of the scale are shown.
The arpeggio notes have been colored in to show their position.*

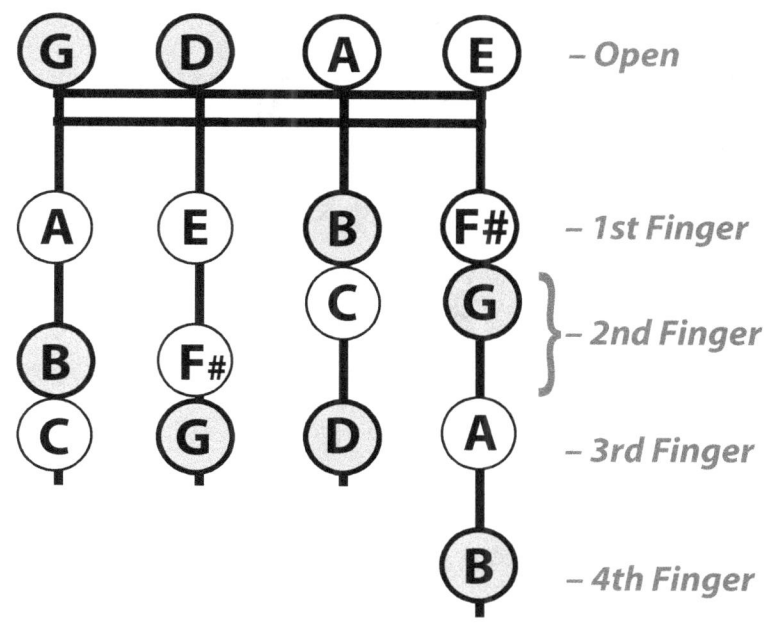

VIOLIN SCALES: BOOK ONE 27

D Major Scale, Arpeggio, and Pentatonic:

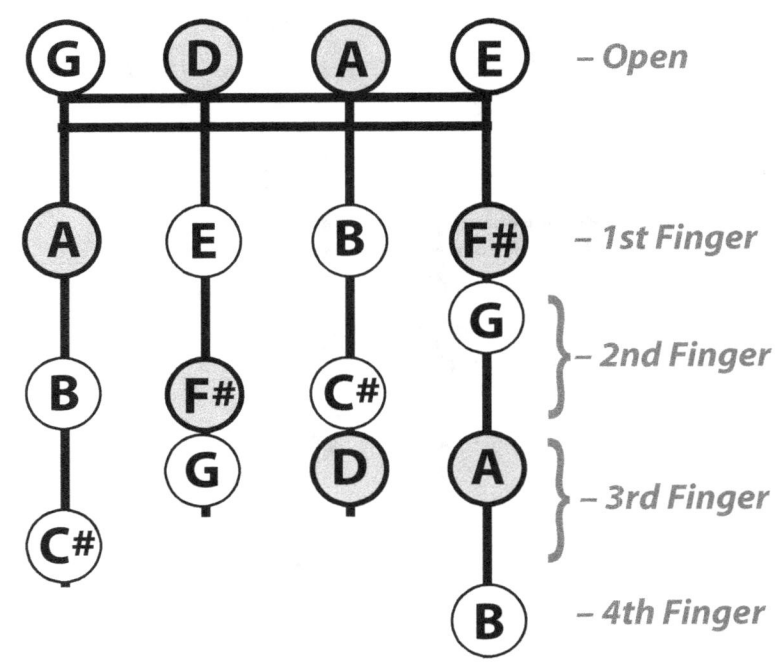

Scale

Arpeggio　　　　　　　　　　　　　　　　　　　　　　　*Major Pentatonic*

A Major Scale, Arpeggio, and Pentatonic:

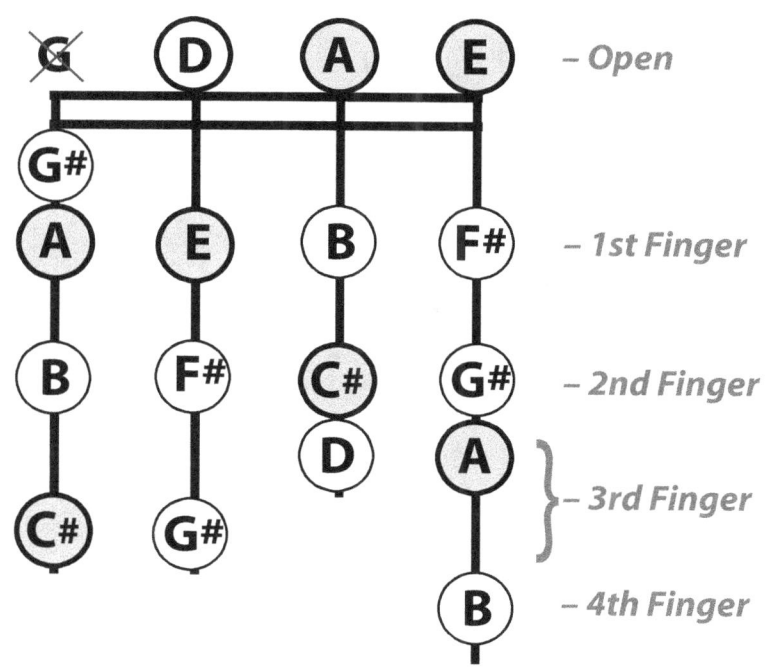

Scale

Arpeggio *Major Pentatonic*

VIOLIN SCALES: BOOK ONE

C Major Scale, Arpeggio, and Pentatonic:

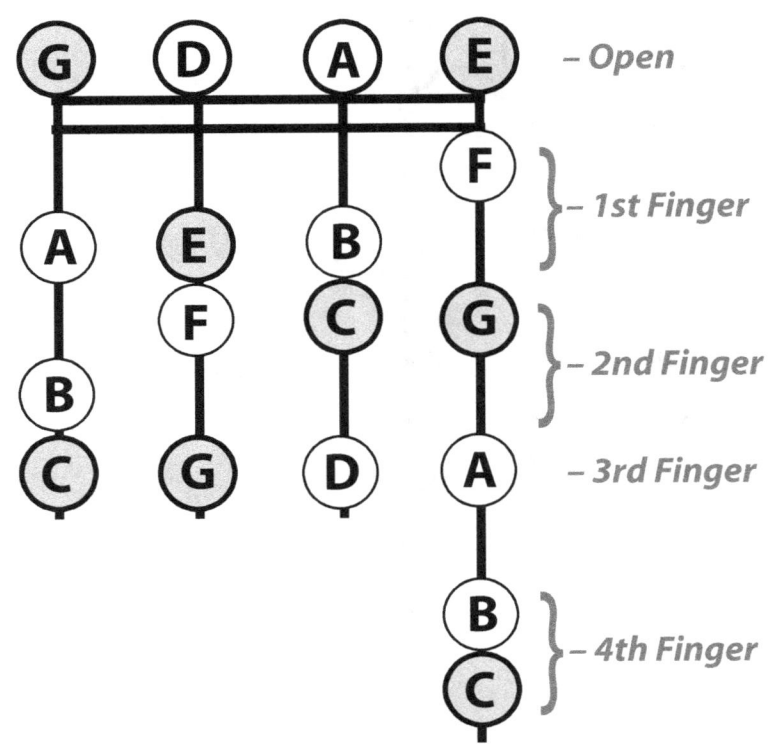

Scale

Arpeggio

Major Pentatonic

VIOLIN SCALES: BOOK ONE

F Major Scale, Arpeggio, and Pentatonic:

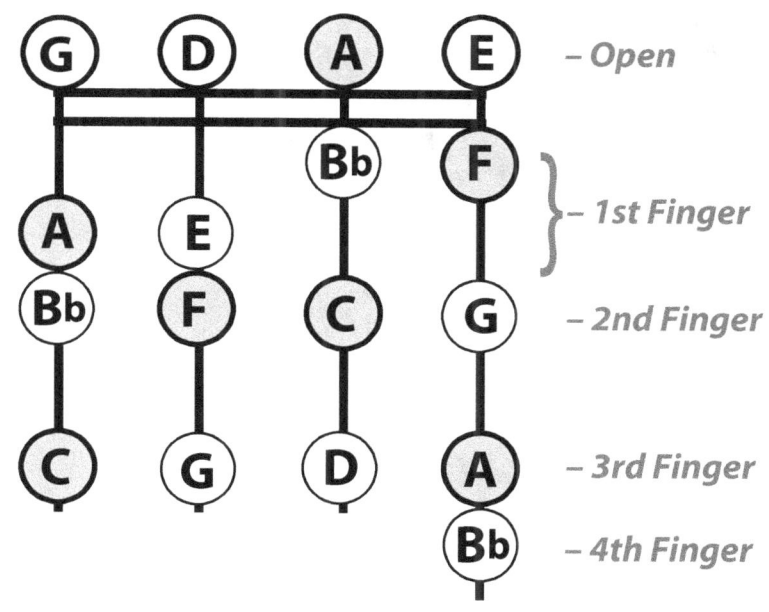

B♭ Major Scale, Arpeggio, and Pentatonic:

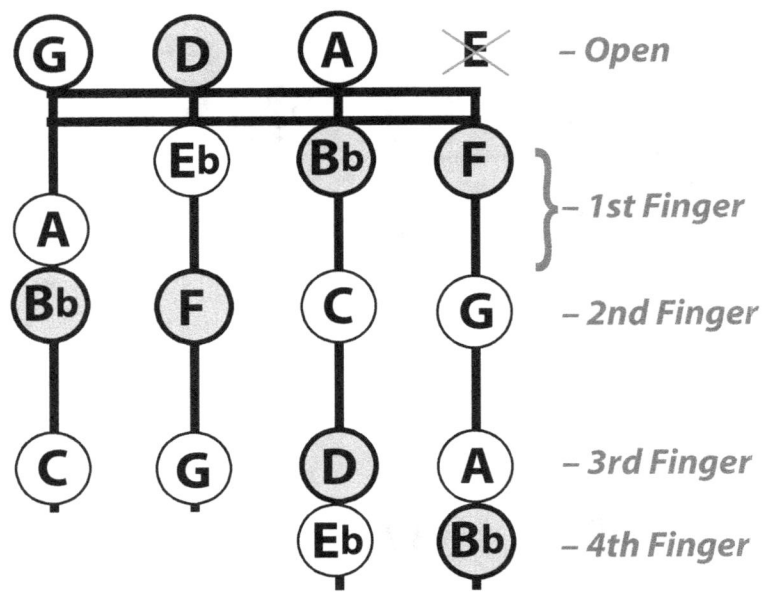

Scale

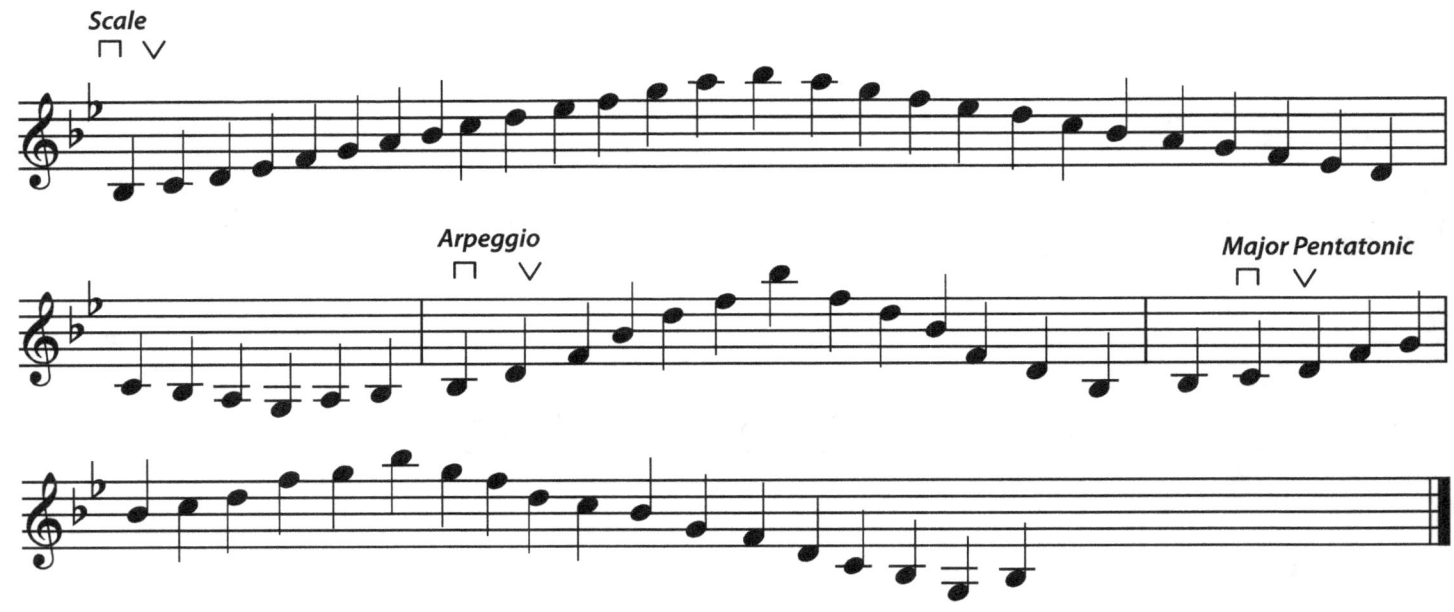

Arpeggio

Major Pentatonic

VIOLIN SCALES: BOOK ONE

E Major Scale, Arpeggio, and Pentatonic:

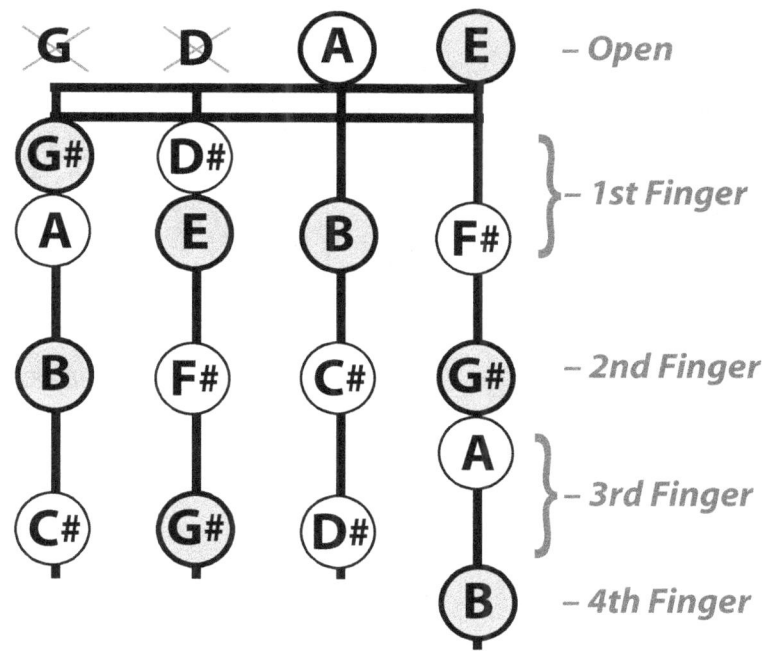

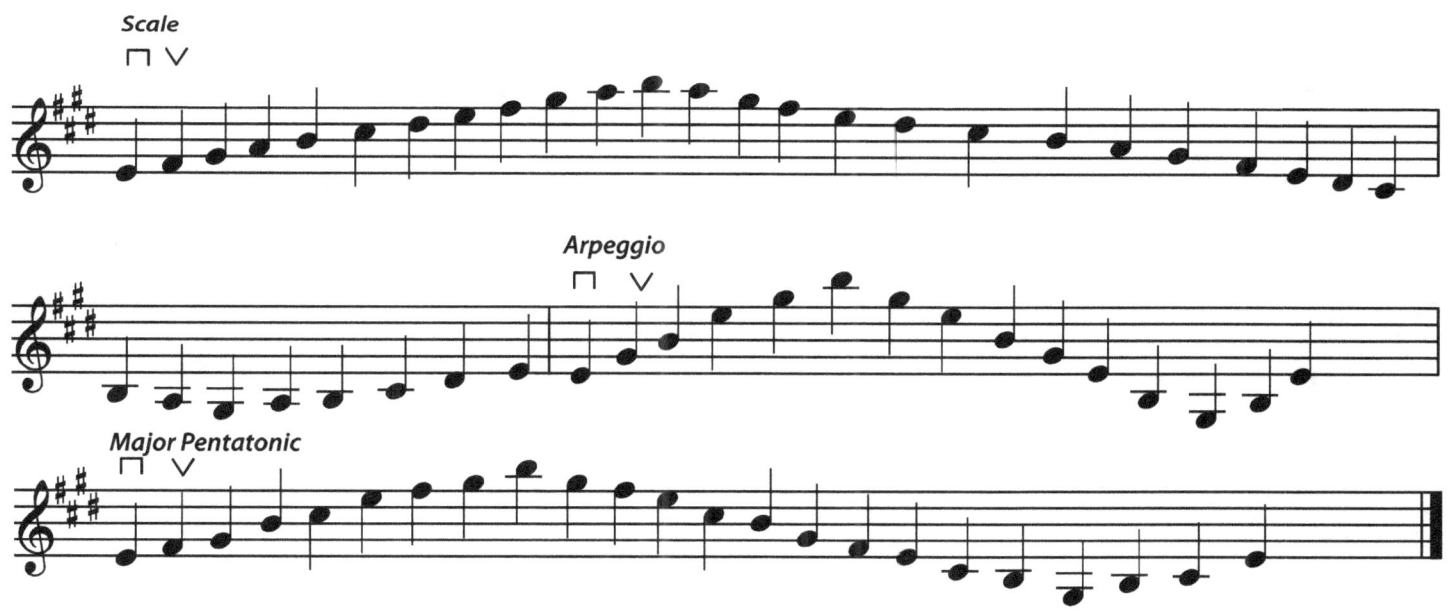

B Major Scale, Arpeggio, and Pentatonic:

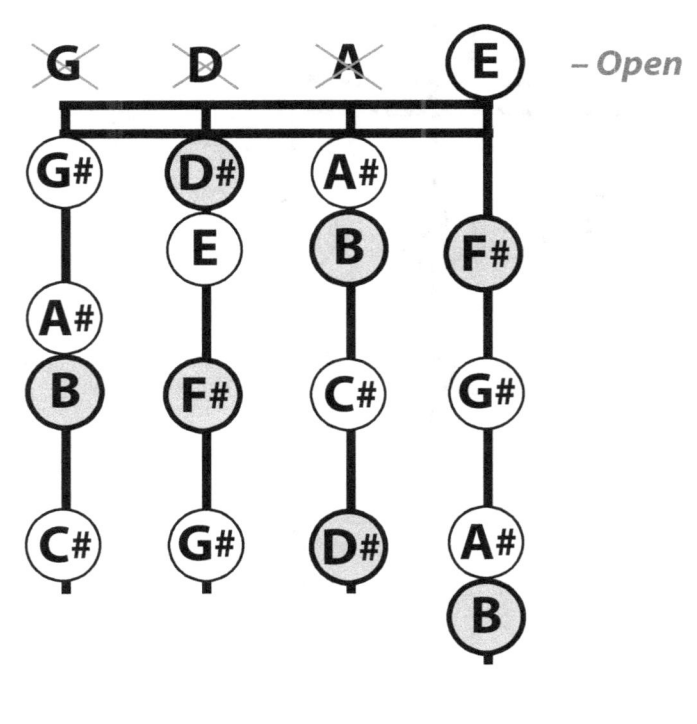

Scale

Arpeggio

Major Pentatonic

34 VIOLIN SCALES: BOOK ONE

E♭ Major Scale, Arpeggio, and Pentatonic:

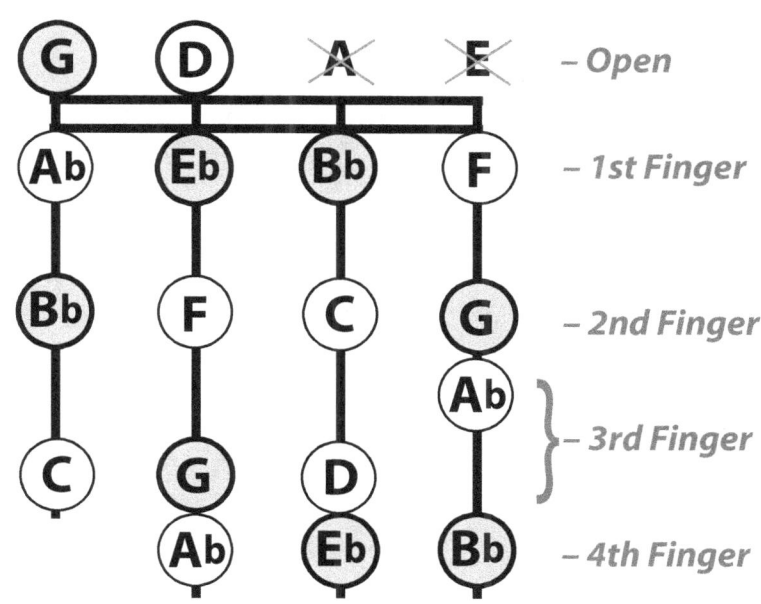

Scale

Arpeggio

Major Pentatonic

A♭ Major Scale, Arpeggio, and Pentatonic:

D♭ Major Scale, Arpeggio, and Pentatonic:

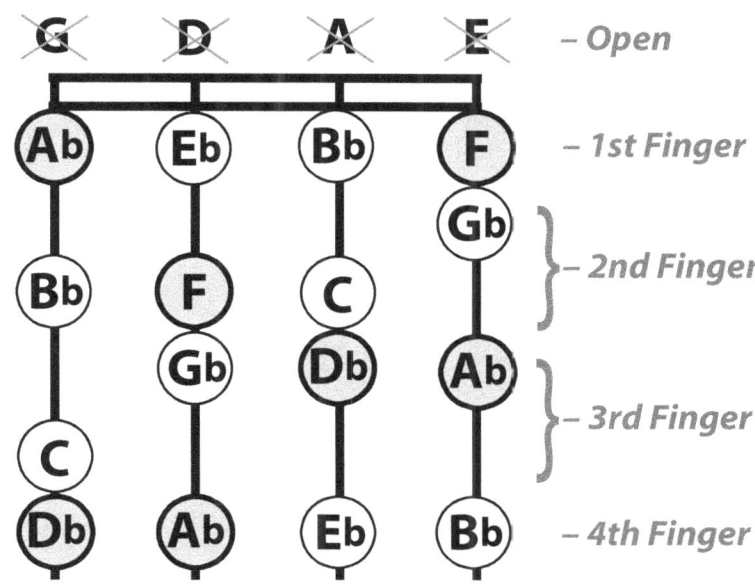

Scale

Arpeggio

Major Pentatonic

VIOLIN SCALES: BOOK ONE

www.ingramcontent.com/pod-product-compliance
Lightning Source LLC
Chambersburg PA
CBHW080853170526
45158CB00009B/2727